DOUBLE ELEPHANT
LEE FRIEDLANDER

DOUBLE ELEPHANT / EDITED BY THOMAS ZANDER

DOUBLE ELEPHANT

Lee Friedlander

STEIDL GALERIE THOMAS ZANDER

15 PHOTOGRAPHS BY LEE FRIEDLANDER

Lee Friedlander behaves so subtly with a camera; his pictures are clad so plainly in his own original style, that you wonder just how his mysterious effects are produced. Wondering, you are brought simply to the fact that the wellspring of all art is forever mysterious — even to the artist.

Friedlander is in his thirties. He seems to have accepted no aesthetic guidance, though he had good technical instruction on the West Coast. He already has had some influence upon younger photographers. His quiet, seemingly unconscious audacity as an artist has been catching. He has achieved recognition among his elders, and from the more alert or courageous establishments such as the Guggenheim Foundation, and from several universities and museums.

To delight you, and possibly to exasperate certain critics, Friedlander has selected these fifteen pictures. They are from the past as well as from recent work. All of them, it will be seen, have the same accent. A view, through an open-bar bedboard, of a television set flashing a gaping baby's face, in one photograph, is a picture that would have been haunting even had the television screen been blank. In another print, a woman's shoe and her ankle emerge insanely from just the right amount of inexplicable shadow. Next, one picture is shot from behind huge, blurred, out-of-focus fingers grasping a highball glass, and centers on two perfect bar-lounge man-and-girl types gazing into one another's eyes, oblivious in their idiotic befuddled absorption. Then there is a snapshot made looking through the reflecting glass of a sedan auto window which frames a double-arrow street sign, a bad World War I doughboy statue, and some factory chimneys — a typical composition, juxtaposition, and superimposition. This is visual oxymoron with a vengeance. He uses that device repeatedly, in other work, almost as a signature.

And so on. Bemusing and sometimes dazzling are these prints from Leica negatives. Seeing a brace of them, it becomes clear that this photographer artist is to be taken seriously even while he is grinning — because he uses photography with deadly aim to reflect and record only his own very special, personal vision of his world. It is oddly refreshing, unselfconsciously striking, and unpredictably adventurous.

Walker Evans
Old Lyme, Connecticut
April 1973

15 Photographs by Lee Friedlander has been published in a limited edition of seventy-five copies, plus fifteen artist's proofs. Each print has been signed and numbered by the photographer. Each photograph was printed by the photographer on Dupont Veralure (VLTW). They are selenium-toned, fully washed in an East Street Gallery archival washer and air-dried. They were mounted on a 615 GSM Imperial 300-pound handmade sheet of paper, manufactured by J. Barcham Green Ltd. The embossing of the paper was done by the Bob Blackburn Workshop. The graphic consultant was Marvin Israel. The text sheets were printed by Ronald Gordon of the Oliphant Press. The portfolio container was made by Rudolf Rieser. The introduction was contributed by Walker Evans. The project editors were Burton Richard Wolf and Eugene Stuttman.

Edited by Lee Friedlander for The Double Elephant Press Ltd., 205 East 42nd Street, New York, New York, 10017.

1

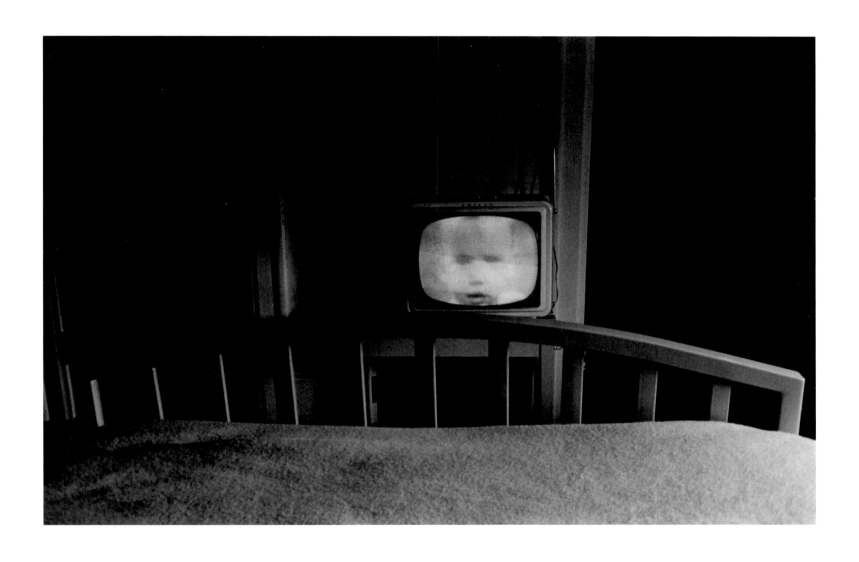

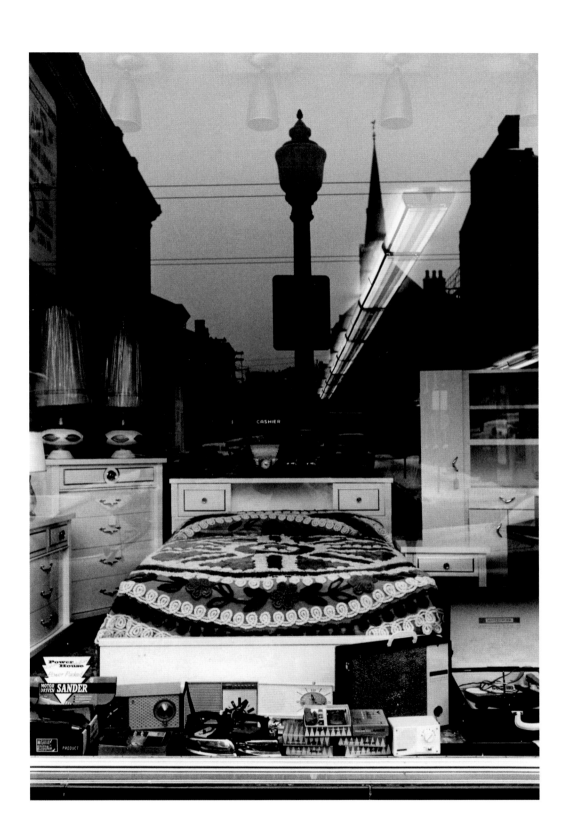

3

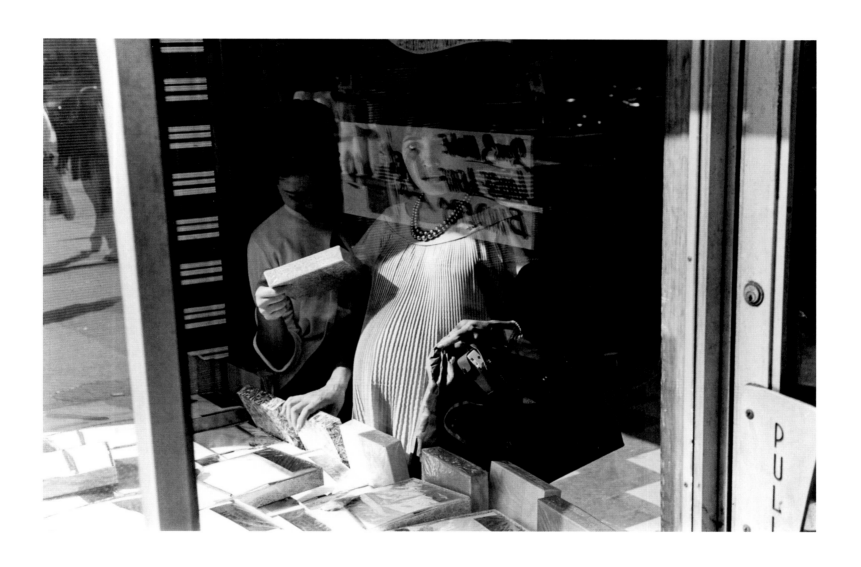

4

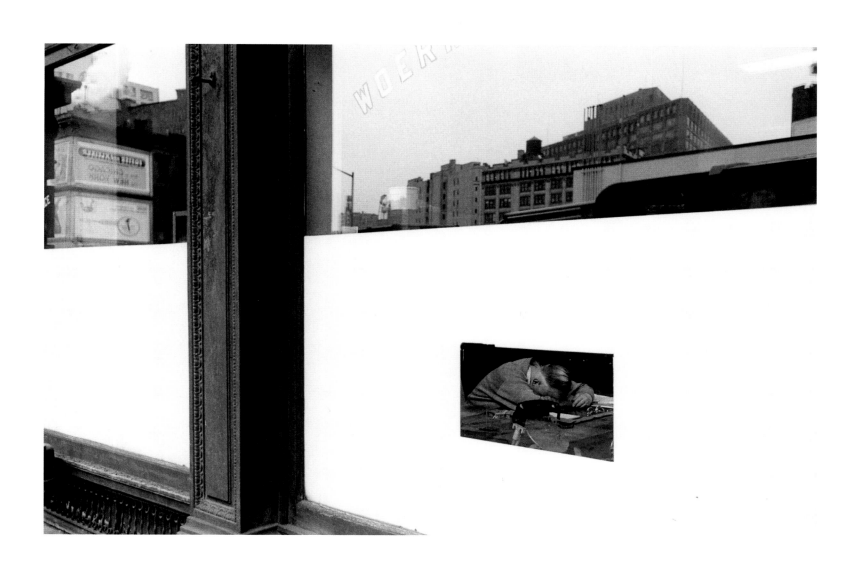

5

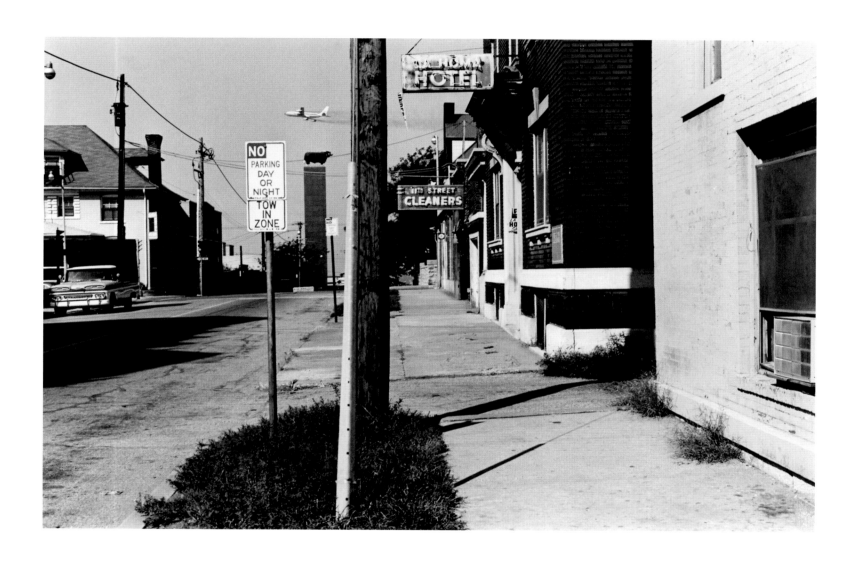

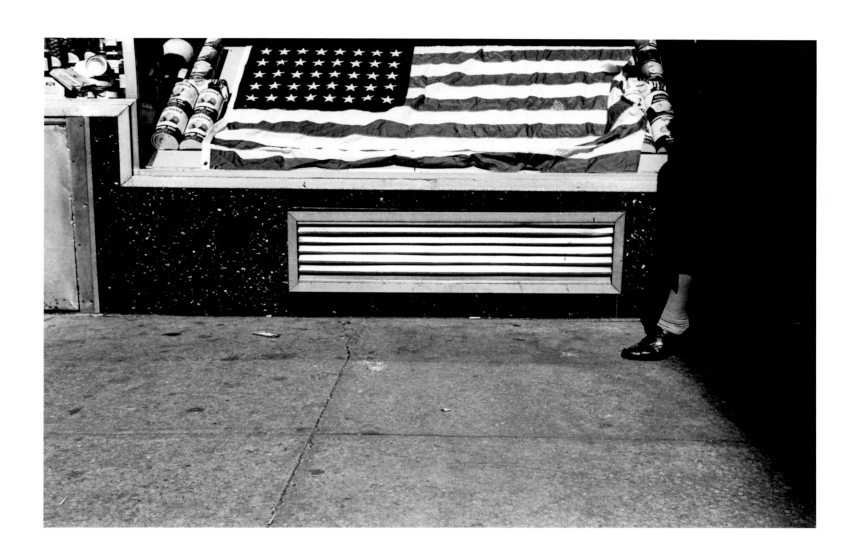

7

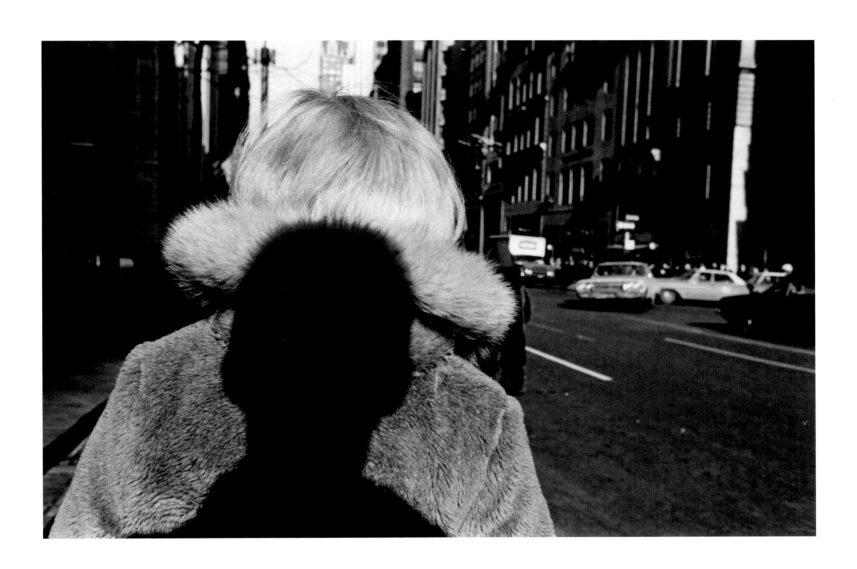

8

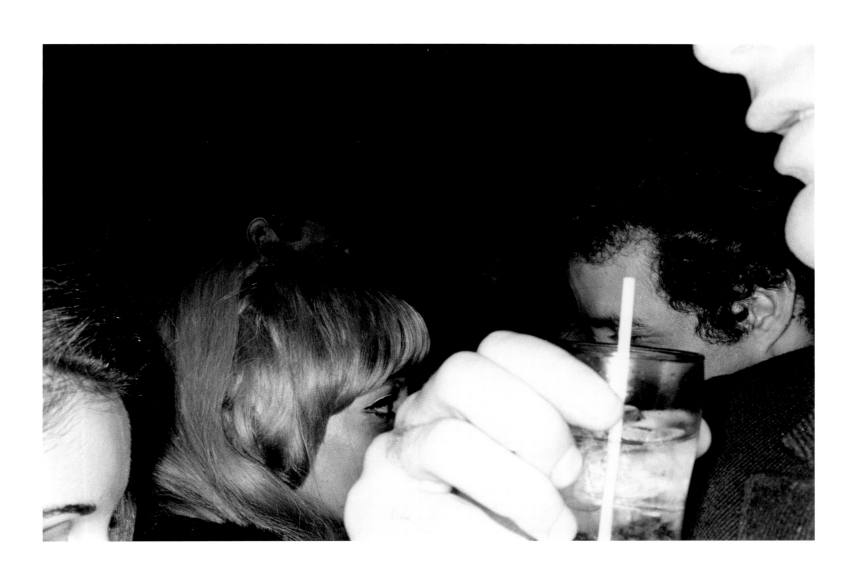

9

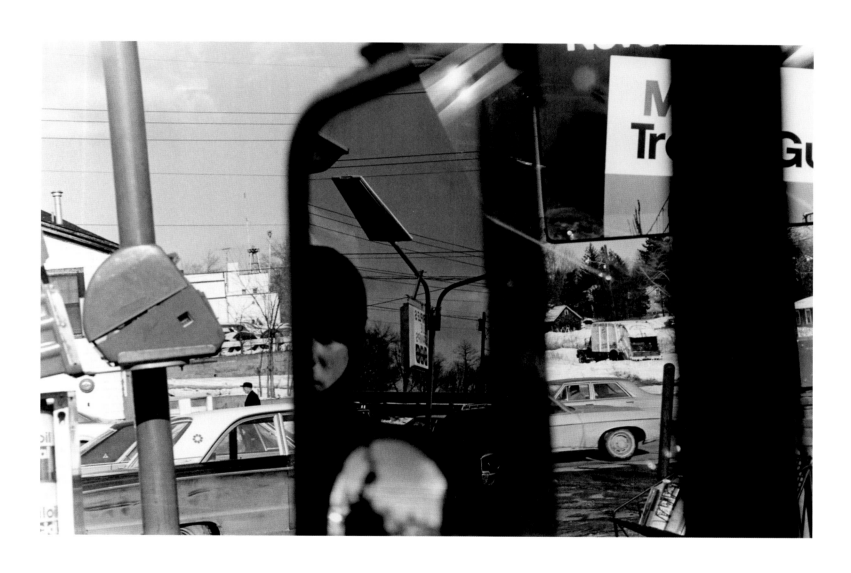

10

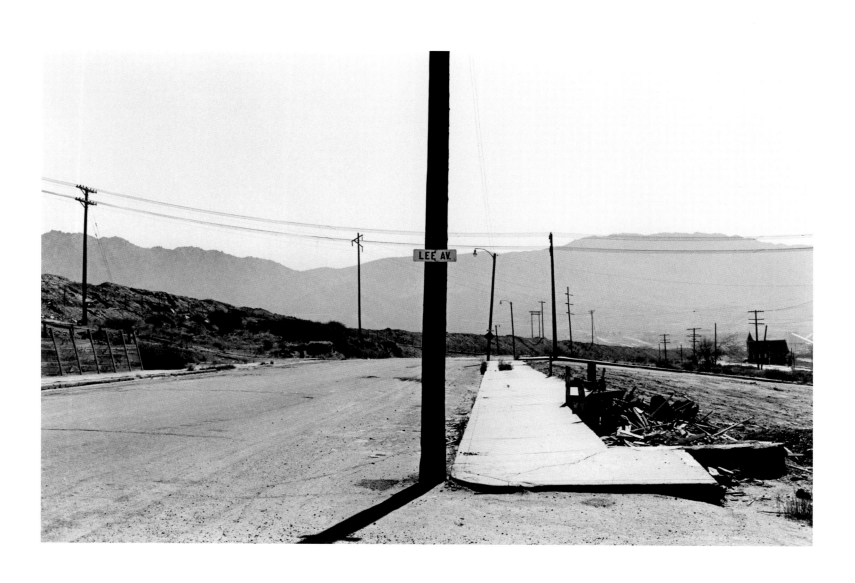

11

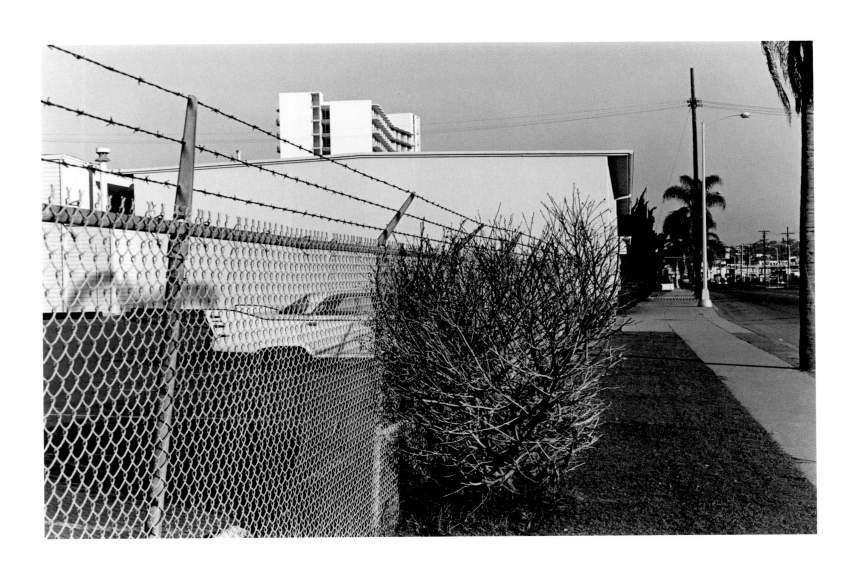

12

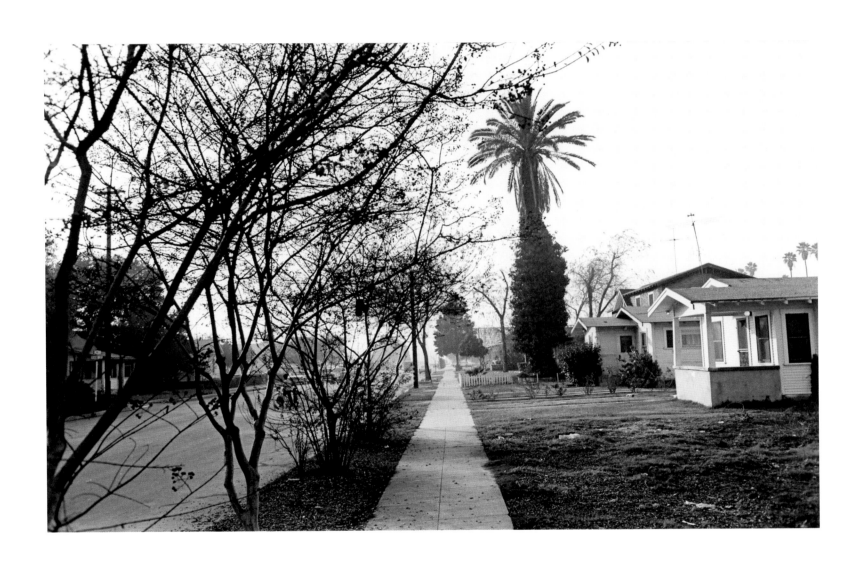

13

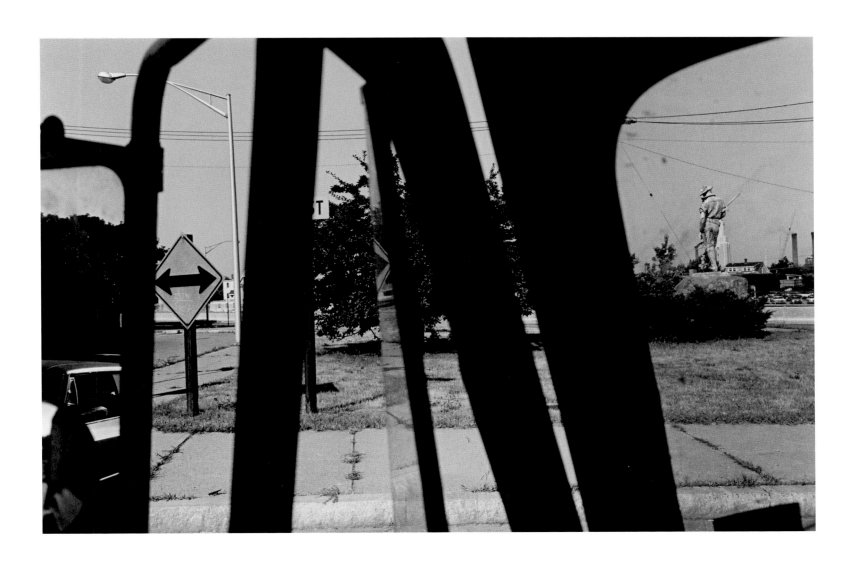

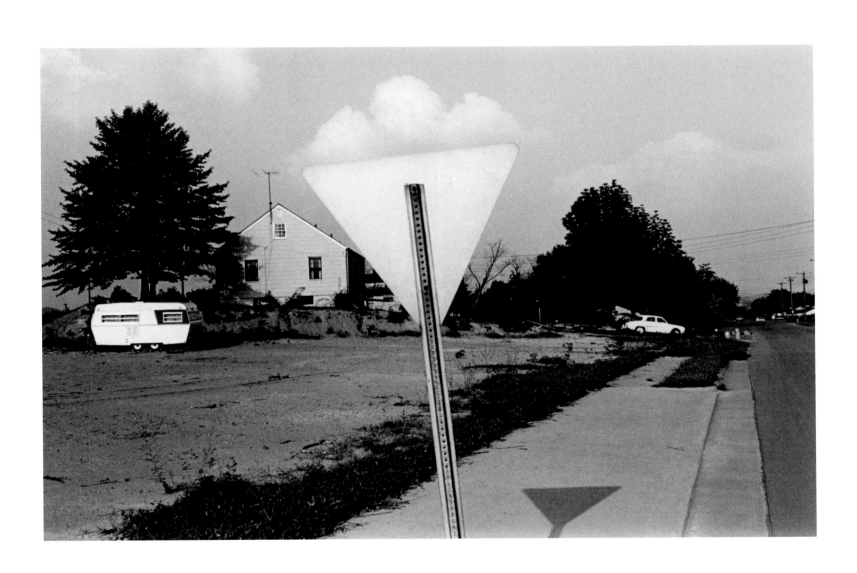

15

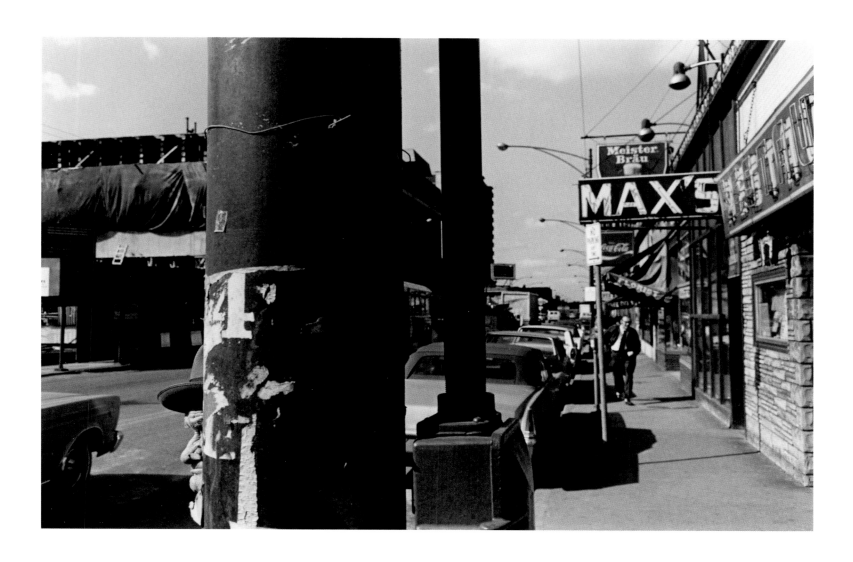

First book edition published in 2015

Image sequence, portfolio description, and introductory
text by Walker Evans from the original portfolio.

Editor: Thomas Zander
Project management: Frauke Breede, Anna Höfinghoff
Copyediting: Keonaona Peterson
Book design: Duncan Whyte, Bernard Fischer, Sarah Winter, Gerhard Steidl
Tritone separations by Steidl
Production and printing: Steidl, Göttingen

Steidl
Düstere Str. 4 / 37073 Göttingen, Germany
Phone +49 551 49 60 60 / Fax +49 551 49 60 649
mail@steidl.de
steidl.de

Galerie Thomas Zander
Schönhauser Str. 8 / 50968 Cologne, Germany
Phone +49 221 934 88 56 / Fax +49 221 934 88 58
mail@galeriezander.com
galeriezander.com

ISBN 978-3-86930-743-5
Printed in Germany by Steidl